MW01078528

ONE-YEAR ART JOURNAL

ONE-YEAR
ART
journal

DAILY PROMPTS
TO SPARK YOUR CREATIVITY

ROCKRIDGE
PRESS

Copyright © 2021 by Rockridge Press, Emeryville, California

No part of this publication may be reproduced, stored in a retrieval system, or transmitted in any form or by any means, electronic, mechanical, photocopying, recording, scanning, or otherwise, except as permitted under Sections 107 or 108 of the 1976 United States Copyright Act, without the prior written permission of the Publisher. Requests to the Publisher for permission should be addressed to the Permissions Department, Rockridge Press, 6005 Shellmound Street, Suite 175, Emeryville, CA 94608.

Limit of Liability/Disclaimer of Warranty: The Publisher and the author make no representations or warranties with respect to the accuracy or completeness of the contents of this work and specifically disclaim all warranties, including without limitation warranties of fitness for a particular purpose. No warranty may be created or extended by sales or promotional materials. The advice and strategies contained herein may not be suitable for every situation. This work is sold with the understanding that the Publisher is not engaged in rendering medical, legal, or other professional advice or services. If professional assistance is required, the services of a competent professional person should be sought. Neither the Publisher nor the author shall be liable for damages arising herefrom. The fact that an individual, organization, or website is referred to in this work as a citation and/or potential source of further information does not mean that the author or the Publisher endorses the information the individual, organization, or website may provide or recommendations they/it may make. Further, readers should be aware that websites listed in this work may have changed or disappeared between when this work was written and when it is read.

For general information on our other products and services or to obtain technical support, please contact our Customer Care Department within the United States at (866) 744-2665, or outside the United States at (510) 253-0500.

Rockridge Press publishes its books in a variety of electronic and print formats. Some content that appears in print may not be available in electronic books, and vice versa.

TRADEMARKS: Rockridge Press and the Rockridge Press logo are trademarks or registered trademarks of Callisto Media Inc. and/or its affiliates, in the United States and other countries, and may not be used without written permission. All other trademarks are the property of their respective owners. Rockridge Press is not associated with any product or vendor mentioned in this book.

Interior and Cover Designer: Linda Snorina
Art Producer: Samantha Ulban
Editor: Eun H. Jeong
Production Editor: Rachel Taenzler
Production Manager: Riley Hoffman

Illustrations © 2021 Collaborate Agency

Paperback ISBN: 978-1-63807-501-1
R0

This journal belongs to:

Introduction

Welcome to this one-year art journal!

Within these pages, you'll find 365 art prompts—one for each day of a year—to draw, sketch, and more. Each one encourages expression, creativity, and art style, and doesn't have to be followed exactly. Have fun with it; read the prompt and complete it in a way that inspires you. That's bound to be different from the way it would inspire someone else—that's the beauty of art! It's not about getting it right, but about taking time out every day to create something. Watching your artistic skill grow over the year should be considered a by-product, not the aim of this book.

By using this journal, you'll be taking part in tasks involving doodling, coloring, drawing, journaling, and creativity in general. There are so many benefits to these activities—not only will you improve your artistic abilities and increase your creative output, but by spending time every day focused on one task, you will also be practicing mindfulness, something that's shown to improve your mental and even your physical health.

It's possible to feel calmer and happier by spending a few minutes every day focusing on one project. Emotions can be released, leading to greater self-awareness and self-knowledge and therefore self-empowerment. There are so many positive benefits to art journaling.

Whether you're at the beginning of your journey as an artist or returning to art after a time, this book will help you get back to your creativity and back to yourself.

Happy journaling for the year ahead!

How to Use This Book

This book was written with simplicity in mind. There is no need to spend lots of money on expensive materials to complete any of the art projects. Most of the prompts require pencil, pen, crayon, or very occasionally paint. However, feel free to use other mediums if you don't have those at hand or if you feel inspired to do so. You could try collage, charcoal, pastels—anything that you'd like.

Art materials range in price from very cheap to very expensive. Again, please don't feel you need to spend lots of money on products. Our aim here is to just have fun and to be creative and mindful.

This is a paper book, and as such, it isn't ideal for working with every kind of art medium. Thick paint might soak through. Dark felt-tip pen can sometimes be seen on the next page. Thick collages might make the book harder to close. But again, this isn't about doing everything perfectly in the designated space. If you want to, and you have the material at hand, it's perfectly fine to complete the task on separate paper or cardstock.

Whatever medium you choose to use, take advantage of it to express your creativity to its fullest. Work with whatever suits you best. Enjoy!

Using only one color, copy the guide to produce a value scale, going from light shades to dark.

The human eye can be so sensitive that it can detect even tiny variations in a single color. Try challenging yourself to color as sensitively as possible while shading these gradient boxes.

Follow this guide to create various kinds of lines, shapes, and patterns. After that, try experimenting with some of your own ideas. This technique is called mark making.

Cross-hatching is a method used to rapidly add shading and texture to an image, as shown in the example of the basketball and cup below. After some practice, try using cross-hatching to draw an often-used object.

Colors that sit next to each other on a color wheel blend well together. Complete the diagram below by filling in secondary colors next to primary colors.

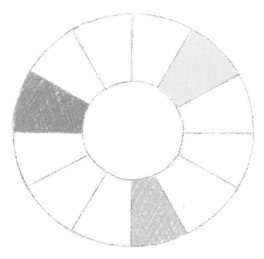

Sometimes opposites attract! Choose two colors on opposite sides of the wheel and draw them next to each other, then try mixing them and see what happens. These pairs are called complementary colors.

What signals the arrival of springtime for you? Is it a change in the weather? Or the awakening of wildlife? Fill this page with art that says "spring."

Use the first frame as inspiration to fill in the others. Try copying the modern art style in the second frame. Feeling more confident? Try your own style in the third.

Inventing new ice-cream flavors might be the best job on earth! Come up with creative new flavors to add to the cones.

Draw some wind swirling through the branches of this tree and in the air. Do different colors create a stronger sense of movement?

Draw the view from your window using only two bold colors. Narrowing your focus might help you notice details you've missed before.

Break down the problem. Start from the basics and build up. Try drawing your own flower using the example below as a guide.

Symmetry can bring a sense of balance and harmony. Illustrate a matching wing for this butterfly.

Consider how a small change can make a big impact. Use some loose, energetic scribbles to make a splash from this puddle.

Simple repetition can be soothing for the mind. Fill each segment with only dots, then lines, and, finally, only stars.

Colors can evoke certain emotions, such as red for anger or blue for sadness. Fill this space by writing about your day using a mixture of colors to emphasize various feelings.

Continue drawing this ribbon all over the page as you think back on a special present you've gifted to someone, remembering the feeling of anticipation as they opened it.

How about trying out an impressionistic art style? Shade this sphere using only dots, creating one seamless image using many small marks.

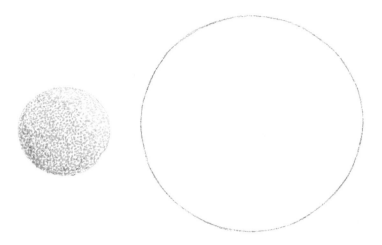

Agree, Along, Alive, Adventure. Think about the beginnings of a journey as you decorate these letter A's.

Practice some cross-hatching on these spheres. Use a range of colors and take note of how using the same technique but a different color can alter the intensity of the object.

Practice some color blending on these different shapes. Does the shape impact how you apply the color?

Use the templates to create portraits of some of the special people in your life. You can try a realistic approach or get creative and emphasize characteristics you admire.

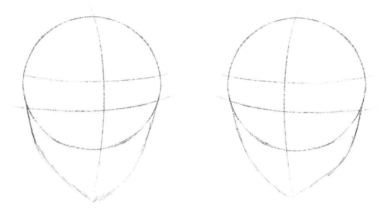

Fill the space with a variety of strokes. Try dashes, dots, and thick and thin lines, and experiment with various colors.

Spring is a time for fresh beginnings and new life. As you fill this space with budding blossoms, think about a journey you wish to embark on this year.

The rustling of pond reeds can create a distinct, relaxing mood. Draw a scene inspired by an afternoon spent lounging by the water's edge.

The sun is setting on another day. Shade the sky in beautiful red, orange, and yellow hues. Use this time to reflect on your accomplishments today, no matter how big or small.

A haiku is a poem consisting of 17 syllables arranged in three lines of 5, 7, and 5 syllables, respectively. Write and illustrate a haiku about your favorite animal from a calming, thoughtful perspective.

Try to draw yourself while staring at a mirror, not looking at the page as you draw. This method lets you practice your hand-eye coordination and also helps you feel less self-conscious about your art as you make it.

Insects are a vital but easily overlooked part of a natural ecosystem. Fill this space with bright, colorful insects of varying shapes and sizes. As you do, reflect on something that makes you happy but that you often overlook.

Bring color to these different feathers using various tones to fill them in.

Try using a variety of techniques to create patterns on these tree branches. Do you prefer abstract, expressive patterns, or do you find yourself drawn to a more ordered structure?

Draw the wool on these sheep. Try experimenting with various line thickness and pattern density to give the wool a range of textures.

Your feelings beneath the surface don't always reflect the way other people perceive you. Draw this swan's reflection using an expressive and surreal style, rather than making an exact copy.

A splash of color can bring a pattern to life. Fill in these plain white spots with colors to create a vibrant mosaic effect. Does it create a style you like?

Being able to understand and re-create a pattern can be a helpful skill in both art and life. Continue this pattern while thinking about how you form your own patterns from your daily routines.

A raindrop has a long way to fall from the cloud to the sidewalk. Fill this space with tiny drops of water, using only cool hues (blues, purples, and greens).

What journey would you take if you could float away on a hot-air balloon? Decorate these balloons with designs that ignite your sense of adventure.

Use your imagination to turn this cloud into a mythical beast. Will you shape it into a fearsome dragon, a majestic Pegasus, or an all-new creature?

Bubbles, Blossoms, Believe, Beyond. Think about the ways people find inner peace as you decorate these letter B's.

Try using shading to cast shadows on this apple from three different light sources. Consider how light affects a surface differently depending on its angle.

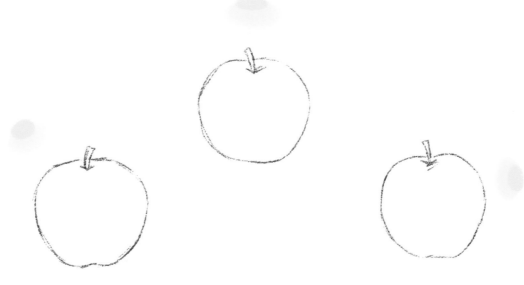

Sea turtles glide peacefully through the ocean currents. Take your time to add a relaxing underwater background of calming, pastel-colored coral.

Give these cubes various organic textures such as fluffy, furry, scaly, or slimy. What kind of textures do you like? Dislike?

Coffee, Cake, Candle, Crystals. Think of simple but soothing experiences as you decorate these letter C's.

Imagine the pitter-patter of rainfall under the safety of a sturdy umbrella. Do you enjoy the rain, or would you be hurrying home? Design some umbrellas you would keep at your home.

Think about what a perfect morning is like for you. Draw a snapshot of what you're imagining.

Bees are critical for the life cycle of many plants and flowers. Draw the flower this bee is about to land on. Try blending two vibrant colors for the petals.

City life can be hectic, but it has its own unique moments of coziness. Draw in the windows of this apartment building. Perhaps you can add a peek inside to get a glimpse of the life of the residents?

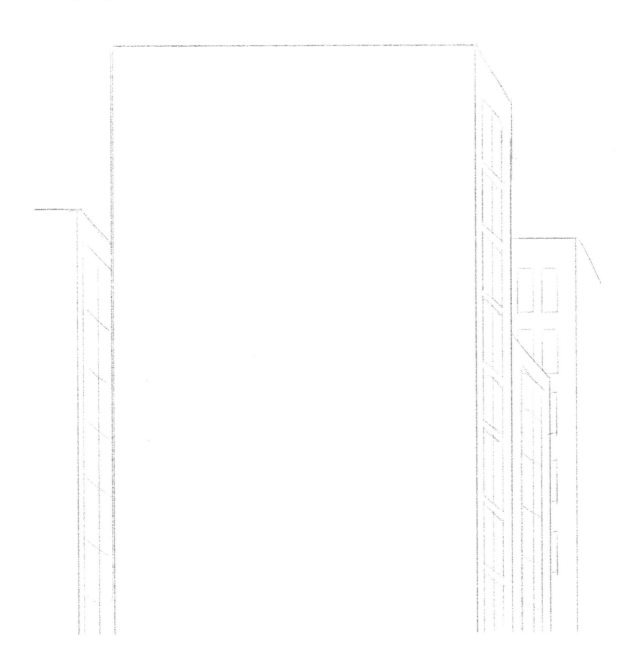

The human mind instinctively fills in the blanks when missing parts of a full picture. Finish the shapes in the space below to create whatever picture your mind fills in.

Life can keep us so busy, can't it? Take today's space to think of something in particular you've been wanting to improve at drawing and spend some time practicing it.

Fill in these hexagons to make a new image. Will you plan it out beforehand or let an image form naturally?

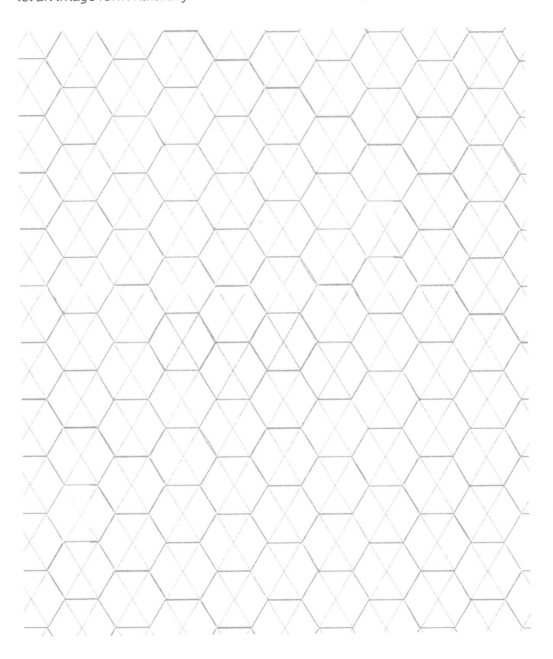

Puff up these dandelion blowballs with fluffy seeds. Are there any worries weighing you down? Imagine them blowing away with these seeds.

It's possible to make sense out of chaos with the right focus. Add details to these scribbles. What can you make from them?

Hands can be intimidating to draw. It can help to focus on one part at a time. Try drawing some hands using your non-drawing hand as a reference.

Shade these rolling green hills, and then bring the scene to life with some small flourishes of detail. Would you like to live somewhere like this?

Dance, Date, Dear, Duo. Think of an intimate event for two as you decorate these letter D's.

Draw petals to finish these flower heads. Try using a different shape of petal for each one. Do you have a favorite species of flower?

Think about a time your perspective on something—or someone—changed. Was it refreshing to see things differently? Try drawing the same object from three different angles.

A mirror can be practical but also decorative. Draw in the frames for these other mirrors. Do they say anything about their owners?

It's healthy to reflect on things that we like about ourselves. Write three qualities about yourself you're proud of, then depict those traits visually in the space below.

Fill this space with different seashells. Consider the unique texture of each one and think about how each was altered by a turbulent sea journey. How has your own journey shaped your unique identity?

Enchanting, Electricity, Elated, Embrace. Think about fuzzy feelings others have given you as you decorate these letter E's.

Our visual memory can influence how we view the world around us. Pick up a nearby object, flip it upside down, and then draw it. Is the unfamiliar view helpful to understanding the object's basic form more clearly?

Reflect on a time when someone helped you overcome a difficult obstacle. Draw a lighthouse and its beam shining over a sea, guiding someone as you were once guided.

Draw some lily pads with water rippling around them. Take some time to reflect on how your actions have affected those around you.

Color in the pattern on this tortoise shell. Use complementary colors on adjacent segments to give it a playful twist.

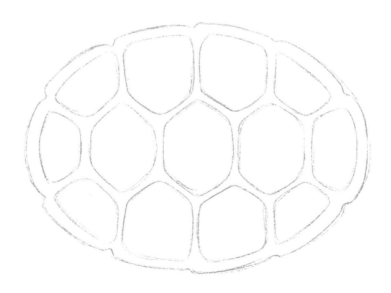

Mushrooms seem to sprout up from the forest floor as if by magic. Use this guide to create a row of mushrooms.

Let your worries float away as you relax in this bubble bath. Try experimenting with blending different colors to create reflections inside the bubbles.

Fancy, Fluffy, Festive, Fresh. Think about outdoor gatherings during springtime as you decorate these letter F's.

Fill your home with greens. Draw some plants from these pots, and try coloring them using the value scale and gradient techniques.

Put on your favorite music and let abstract art flow out of your pencil. What types of lines, shapes, colors, and patterns feel in tune with the rhythm and beats?

Some resilient plants flourish despite their surroundings. Continue the vines growing along this fence as you think about how you have grown past obstacles in your life.

Groovy, Giddy, Gusto, Glow. Think about dance moves that light a fire in you as you decorate these letter G's.

Fill this space with blue objects only. Consider which objects you are drawn to. Do you feel like the existing environment influences your choices?

Draw a personal belonging that has special meaning to you. Try to express this emotional significance through color and texture.

Being left out to dry doesn't have to be a bad thing. Sometimes we all could use a break to let our worries evaporate. Add some laundry to this clothesline.

Fill this page with a summer-themed mural. Consider which summer foods and activities have personal meaning to you.

Using only two colors, create a dynamic design for this beach towel.

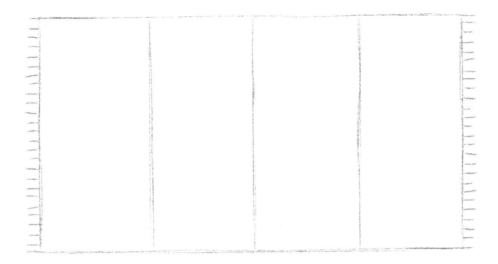

Feeling hungry? Draw your favorite summertime snack to satisfy your craving.

Fill this suitcase with things you would pack for a faraway vacation. Would you travel for self-reflection, relaxation, or sheer adventure?

Draw the reflection of this daytime scene but set it at night.

Happy. Helpful. Hearts and Hugs. Decorate these letter H's with an uplifting vibe.

What's something so vital you don't leave the house without it? Draw it below.

How can certain colors change the entire mood of a scene? Color one version using only warm tones (red, yellow, orange) and the second using only cool tones (blue, green, purple).

Mandala patterns can be used to help guide meditation and focus. Center yourself, and create your own patterns to complete this mandala.

Color these tropical leaves using a blend of blue and yellow rather than green. Experiment with different ratios of each color and see what you prefer.

Populate this space with a cluster of dragonflies. Follow the step-by-step guide as you imagine a peaceful pond for them to fly over, and try experimenting with the body designs and wing patterns on each one.

When viewed extremely close-up, some mundane objects can have fascinating textures. For example: wood, an orange peel, or a mossy stone. Try illustrating a couple of textures you like in detail here.

Fill in this street with more houses as you think about a neighborhood that would be fun to visit. Maybe add some variety to the houses here to reflect that.

Write a haiku about the sea, then decorate this bottle to match your poem.

Ocean currents have a natural ebb and flow. Fill this space with your own waves, alternating their length and height to suggest movement.

Think about the relationship among a light source, an object, and the shadow created when the two meet. Draw shadows from these vases.

Sometimes the absence of something—or someone—can help clarify your emotions. Try creating a negative space drawing of an object by filling the space around it to reveal its shape.

Impact, Impressive, Insight, Iconic. Decorate these letter I's while thinking about cultural figures who have made their mark on your life.

Use the first frame as inspiration to fill the others. Try copying its pointillist style in the second frame, but be creative with any style you like for the third.

Fill these shapes with color going from dark to light. Reduce the pressure of your pencil and feel any stress fade away.

This peacock phased through from another dimension. Give it some reality-bending plumage using abstract shapes and vivid colors.

You're flying to a deserted island and can only bring three things. Think carefully on what you'd take, and draw them here.

Lanterns aren't just a light source. They're also for decoration and celebration. Shade in these lanterns using a gradient from light in the center to dark at the edges.

Create a blind contour drawing of a nearby object. Try to capture its basic form using one continuous line without looking at the paper, and without the pencil leaving the page.

Fill the word below with soothing patterns. Play with line weight and length to discover a technique that feels the most calming.

Design a stained-glass window around the theme of a perfect summer's day.
Maybe you could try using a preexisting image you like as inspiration?

Create colorful patterns on these bunting flags to celebrate your favorite holiday.

Pick your favorite book—or a book you've read recently—and take a shot at redesigning the cover art.

Slice these fruits in half by drawing a sectional view of the inside of each one. You could use a reference image or draw from memory.

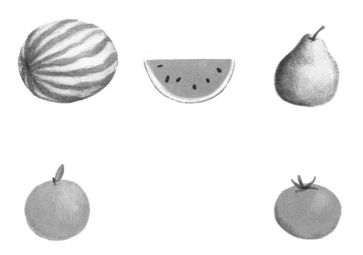

Jaunt, Jazz, Jest, Jolly. While decorating these letter J's, try listening to an upbeat song and see how it affects your art.

Take a moment to reflect on your day, and pick a few words that describe it. Carefully choose a lettering style and color for each word that will emphasize its mood. For example, if you had a bad day, you might scrawl a word in rough, jagged letters with a heavy outline.

Give these spheres some wild animal patterns. For example: tiger stripes, leopard spots, or fish scales.

Think about someone you respect a great deal. Decorate this space with things that represent why you admire them.

Doorways let us pass from one place to another, but they can also be noteworthy pieces of visual design of their own right. Try depicting a grand doorway, either real or imagined.

Think of what "quiet" and "loud" mean to you, and try drawing things that represent them here.

Jars are best when they're full of something tasty, such as smoothies, pickles, or fruit jam. Try using texture and color to fill each of these jars.

Continue this snake's body and create a pattern for its scales. Have you ever observed a snake slithering up close?

Add some plants to these terrariums. Do you prefer a low-maintenance cactus or a fussy but elegant bonsai?

Kudos, Keepsake, Kindred, Knowledge. Think about how people can support and inspire one another as you decorate these letter K's.

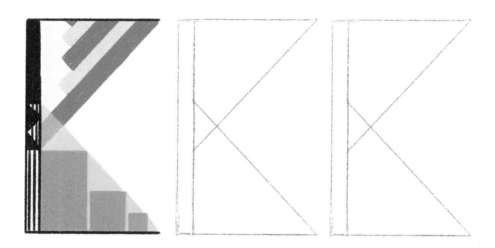

Illustrate one or more oxymorons in creative ways. Here are some examples: bittersweet, organized mess, minor crisis, silent roar.

The world can feel busy and relentless. Enjoy a moment of quiet reflection as you color in these crashing waves as they lap against the shore.

Precious gems are already a marvel, but cutting them into different shapes adds a new level of beauty. Try shading them in your favorite colors to wear.

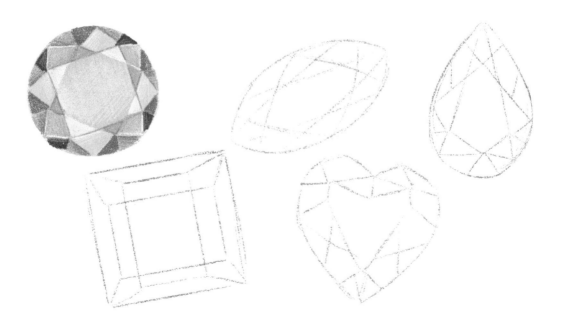

Draw a visual interpretation of the sounds these instruments make, and think beyond just musical notes. Listen to a recording if it helps!

Try illustrating some latte art in this cup, and consider the ways preparing food and drink itself has become a type of art form.

Think of someone you admire, and write their name. Decorate it in an artistic way that reflects the traits you most respect.

Loyalty, Laughter, Lessons, Love. Try decorating these letter L's in the spirit of things friendships from long ago gave you.

Fill these squares with different wooden textures. Tree bark, planks, logs, flooring . . . see if you can find a reference nearby. Wood has so many different uses. Think about ways you'd like to become more versatile in your art.

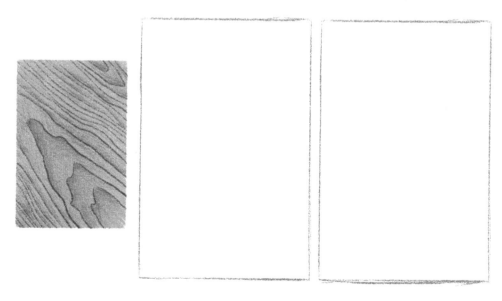

Illustrate the smaller versions of this nesting doll. Vary the colors or features for each one while keeping the style consistent.

Draw the cycle of lunar phases. Does your life feel like it goes through a similar pattern of waxing and waning phases?

Create an abstract illustration of a landmark you know well. For example, a bridge, a statue, a park, or building. Don't worry about the details. Try using bold shapes, lines, and colors.

All aboard! Tickets, please. Fill in the name of your destination with a small promotional image that might be recognizable.

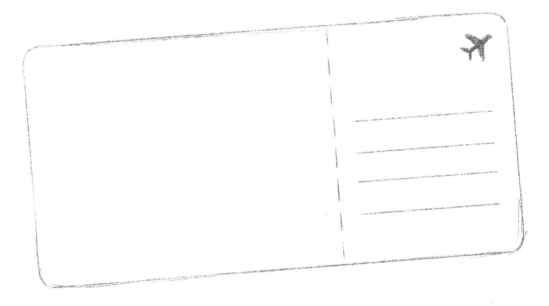

Create negative space art portraying your initials by filling the space around it with abstract shapes or patterns. Make them soft, bubbly, or spiky depending on your personality.

Try drawing different objects that have a similar color overlapping each other, then color over them at the end.

Pick a random page in a nearby book or magazine. If you don't have one handy, open an app and draw the first object you read about or see.

The light from a candle's flame can flicker and move in a way that feels alive and delicate. Try depicting a flame and its light in a way that gives it motion.

There are some things in life which can be solved by restructuring and simplifying. Now take an object you're very familiar with, and try depicting it without lines or without color.

Merry, Magic, Miracle, Mercy. Think of a moment in your life when something seemingly impossible but memorable happened as you dress up these letter M's.

Size plays its own role in our impression of the world. Draw something that is usually big and something usually small beside each other but reverse their sizes.

It's time to bring out your green thumb and create a brand-new type of flower that doesn't exist! Give it a proper name, and describe special features it has.

Fill this beach scene with some visitors—or residents! Tourists, pets, or wildlife: a beach can be full of all sorts.

Try to illustrate the front page of an art magazine. What kind of style will you go with? What's the headline subject?

Try re-creating or even redesigning a favorite childhood toy. What about it appealed to your younger self?

Hairstyles are a way that people express themselves. Play hair stylist for these folks, and give them some special haircuts.

Fill this bowl with some illustrations of fruit but give them a twist by mixing their colors all around.

Think of something you use every day but haven't touched today, then try drawing it from memory alone. Compare it to the real thing: Did you forget any details?

What's the first thing that comes to mind that represents your country? Design a new flag inspired by it, considering how it makes you feel about your nation and why.

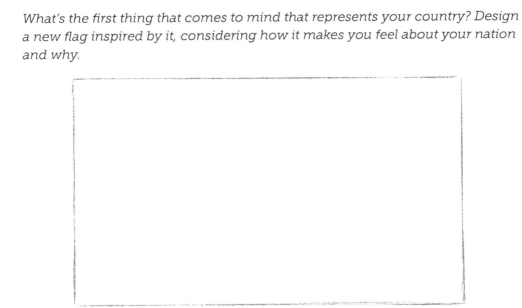

Draw a silhouette profile (side view) of someone you know. If it helps, let yourself draw someone fictional.

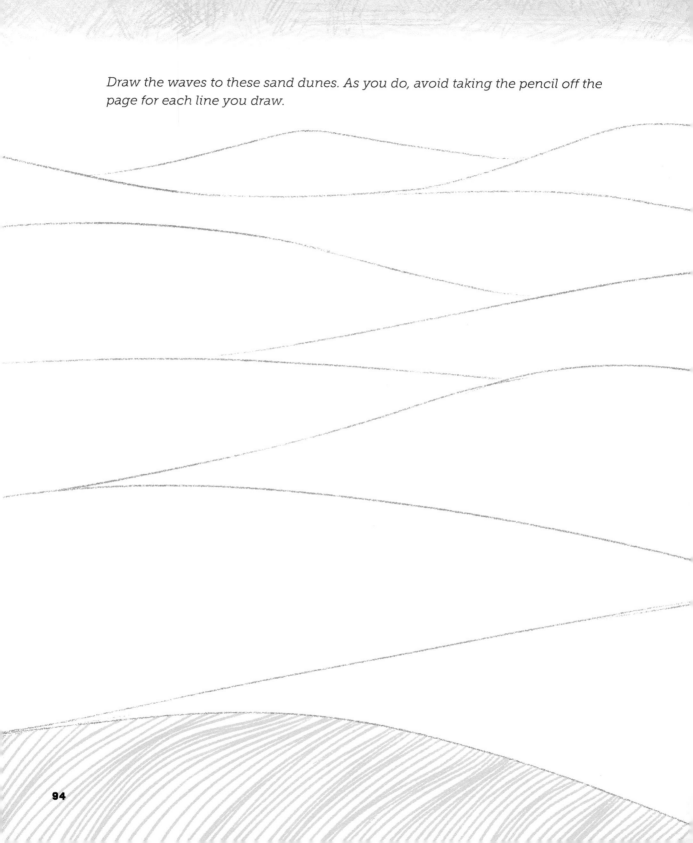

Draw the waves to these sand dunes. As you do, avoid taking the pencil off the page for each line you draw.

A thunderstorm can simultaneously be intense or soothing. Illustrate a thunderstorm below in a way that captures how they make you feel.

Finish this row of beach huts. Are they orderly and identical, or does each resident give their hut a unique touch?

Illustrate this feline's fur coat, giving it a pattern never seen before in nature.

Think of one small action you can do to move closer to a dream of yours. Write it down here, and give it a fitting illustration.

Design a coat of arms for yourself. Think about what values are important to you or hobbies you enjoy, and how to express them in a single design.

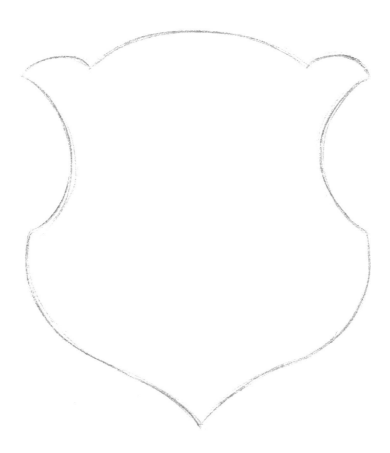

Change is natural in life. Draw an ice cube during various stages of melting. Place one in front of you for reference if it helps.

Coordination isn't required in a group, but it can make things fun. Decorate these surfboards with designs that share a theme.

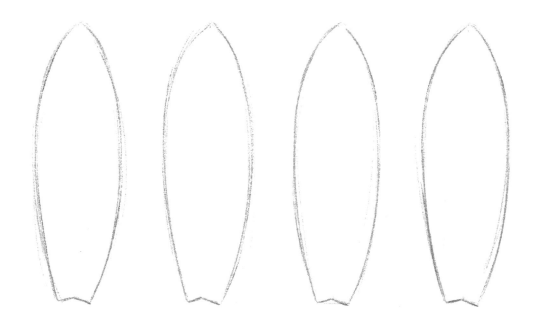

Think back on a time you saw something more clearly when you took a moment to see it from a calm perspective. Draw some boats and their reflections on a still lake.

Think of a lyric from a song that has stuck with you. Write it below, and illustrate around it in a way that expresses how and why it's special to you.

Creating art as a form of meditation allows us to enter a state of focus and flow. Think about how a school of fish moves as one and let your drawings weave around the page.

The little things can help keep us going. Illustrate something seemingly small that brightened your day recently.

They say walking a mile in someone else's footsteps helps you appreciate who they are. Try drawing a path of footprints using different feet and colors as you think back on times you gained greater understanding by experiencing something different.

Draw a simple nearby object six times in a row. Do you find yourself changing them a bit each time or trying to keep them identical?

Cacti are known for their resilience as well as their needles. As you draw a set of cacti here, think of your own traits that help protect you.

Connect lines to the dots to create a new image, allowing some to overlap each other. Shade in the shapes you create to add depth.

Think how we typically see a diamond: sharp, clean, with straight edges. Now try creating a version of it that's soft and squishy.

Create some unique flavors and shapes of ice pops. Come up with two delicious types you've never had, as well as one you'd find gross but that your friend might enjoy.

Decorate this page with colors and imagery that say "autumn" to you as you reflect on the season. Perhaps there are certain sights, sounds, smells, or tastes you're looking forward to?

What's one thing that you love unconditionally? Illustrate your passion for it here.

The right tool for a job might not be the obvious choice. Shade this rectangle with a graphite pencil to represent storm clouds, then use an eraser to create lightning bolts.

Leaves change color as they fall, and that change can bring new life to the world around them. Draw some leaves here, depicting a change from green to red, orange, yellow, and brown.

Flowers don't typically grow underwater . . . but what if they did? Try creating a unique flower that looks familiar to the ones we know, but that grows on the seafloor.

Try drawing a nearby outside view as it looks in the early morning and late at night. Do you prefer how it feels at one time over the other?

Sometimes we're not as familiar with something as we may think. Try drawing an object you use every day without looking at it. How close did you get?

Mushrooms lend themselves well to experimentation. Try drawing some with different shapes, colors, sizes, and patterns.

Design the wallpaper in this room using only two complementary colors (on opposite sides of the color wheel).

It can occasionally be difficult to explain our passions to others. Draw something you adore but illustrate it in as little detail as possible while keeping it recognizable. Try showing it to a friend, and see if they recognize it!

Imagine the delight of visiting a bakery as you fill this window with sweet treats you'd want to pick up.

Pick a small object, and shine a light on it from an angle. Trace the shadow's outline on this page, and try creating a drawing from it!

Rivers don't exist on their own—they chain together to form vast networks. Draw a river delta from above. Look for references if you want to.

Try tracing the outlines of some leaves over top one another on this page, then shade and color in the shapes to create something pleasing.

Navigate, Nestle, Nook, Nurture. Reflect on a time and place where you were surrounded by nature as you decorate these letter N's.

Have you ever spent a day just relaxing, adrift with no plans and no worries? Fill this space with different kites on a nice, uplifting breeze.

Illustrate a sky over this landscape that expresses how you're feeling today. Cloudy, starry, stormy, sunny, or strange?

Draw four self-portraits: one in 15 seconds, one in 60 seconds, one in 5 minutes, and one in 15 minutes. Are you able to adapt to different styles for different lengths of time?

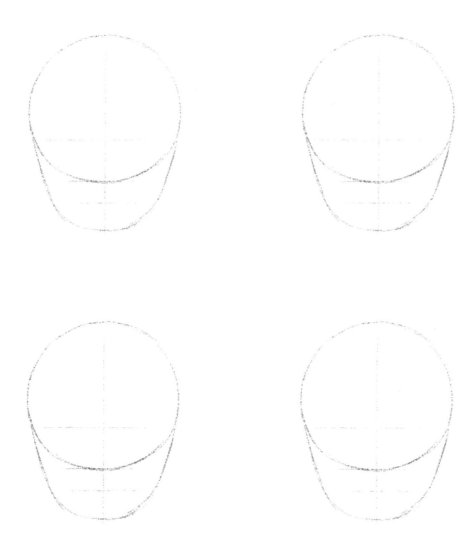

What awaits on the other side of this door? Try illustrating where you'd like to be right now.

Use the first frame as inspiration to fill in the others. Try copying the pop art style closely in the second frame, then invent your own style for the third.

Draw leaves falling from these branches. Reflect on something you've let go that had a positive impact on your life.

Draw some unique and tasty cocktails and mixed drinks! Try using different colors and techniques to portray various textures and flavors.

Fill this space with colorful fireworks. Consider experimenting with different designs, textures, or line styles to make each explosion unique.

Draw some pumpkins, and give them faces. Exaggerate the shapes and sizes to mimic different sorts of people you know.

Is there someone you want to reach out to and connect with? Try illustrating them here or something that reminds you of them, and maybe send them a message afterward.

Complete this scarf. Do you want to follow the pattern that exists already or try transforming it into a new pattern partway through?

*What accomplishment are you most proud of? Give yourself a trophy for it!
How might it look? What title does it bestow?*

*Being woken up by an alarm has a distinct sort of feeling. Try illustrating what
that feeling is like for you using abstract art.*

Try going outside or retrieving some natural objects. Examine them up close, and re-create their textures with close detail.

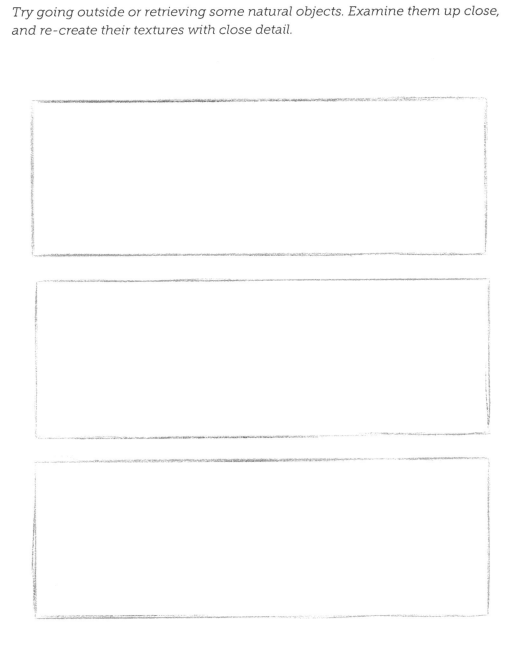

Try designing a postcard to someone you love, sent from a place you love.

Draw the face of someone you love without a reference, then try with one. What kinds of differences stand out?

Bamboo bends in the wind but doesn't snap. Reflect on someone you've met who reminds you of this flexibility or resilience as you fill in this bamboo forest.

Create a still life image using these prompts: a piece of fruit, an object you used today, and a cup or mug.

Zen gardens use physical space to help calm the mind. Draw the lines in this Zen garden.

Reflect on a time when you overcame a fear. Now try depicting that moment in as literal or abstract a way as you wish.

Oasis, Odyssey, Onward, Opportunities. Think of a time you were able to see or do something special you never thought you would as you decorate these letter O's.

Design your own superhero insignia. What does it represent? What kind of struggles does this hero overcome?

Illustrate what "world peace" looks like to you.

Draw three fruits, but mix around their properties (for example, a banana with an orange peel or a bunch of grapes in the shape of a banana).

In each segment, draw a different part of the day and night cycle. Which time of day are you most focused during?

Cook up an ultimate pizza for your personal taste by adding ingredients to this pie. Try imagining each flavor by itself as well as how they work together.

Polite, Peaceful, Positive, Paradise. Decorate these letter P's with thoughts of what the ideal place to live looks like to you.

Go with the groovy flow, and color in these lava lamps to give each one a distinct vibe.

Try looking up a "Word of the Day" somewhere, and depict it in visual form here. If you can't find one, pick a personal "Word of the Day" for yourself.

Using two pencils in the same hand, close your eyes, focus on your breathing, and let your hands move gently across the page for a bit. What does the result make you think of?

Try to remember a fond memory from when you were younger, and depict it here in any way or style you like.

Illustrate a fire using only cool-toned colors (blues, greens, purples). Try blending the color combination in an unexpected way.

Quiet, Quiz, Question, Quench. Satisfy the thirst for knowledge for these letter Q's while you decorate them.

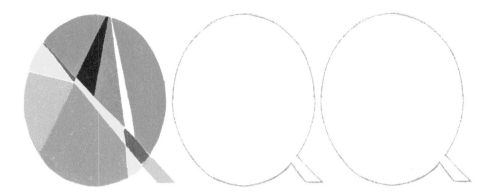

Today, try illustrating something you adore from your bedroom, and depict it in a way that could show a stranger why you love it so much.

Keep it together as you try drawing a self-portrait using both of your hands: one for each side.

If you could buy anything from your favorite shop, what would it be and why? Depict it here in all its glory.

Try drawing close-ups of the textures of three everyday items. Follow the example of a cotton T-shirt. Pay attention, and look for details you haven't noticed before.

What do you go to when you need some comfort food? Try illustrating it in a stylish way that highlights why it soothes your soul, and add more plates if you want.

There can be beauty in the unknown. Draw a nice layer of fog and mist covering this forest scene.

Sometimes it's not what is said, but how. Make onomatopoeia art out of these word prompts: "BANG," "FIZZ," "POP."

Try playing some music you've never heard before by an artist you don't know as you create the cover art for their next hit single.

Create a new species of flower that has adapted to the coldest temperatures. Try showing how freezing its surroundings are.

Whether you're looking for constellations, contemplating your place in the universe, or just enjoying the sights, try filling up this area with stars.

Imagine what the ideal view out of your window would be, and depict it here. Is it somewhere you just daydream of, or a place you'd actually like to live?

Choose three objects from nature, and practice using only straight-line strokes to draw and shade them.

Fill this page with symmetrical and asymmetrical patterns alike. Mix and match, or contrast and compare to reflect on how each style of pattern can be pleasing in different ways.

Draw in waves crashing against this shore. Try to capture the energy of the waves. Is the water relatively calm or churning with speed?

Try depicting in black and white something known for its bright color. Can you use shading or patterns to keep it vibrant?

Find something transparent or translucent to illustrate. A bubble, a clear container of water, something glass . . . see if you can capture the way light plays with it.

Tree trunks leave rings as they grow and expand outward. Add more rings to this tree trunk. How old is it to you?

Draw a simple landscape around this plain cottage, using muted colors to keep things calm and subdued.

Get a reference of your own eyes and illustrate one of them here in as realistic a way as you can.

Close your eyes, and draw one long, continuous squiggly line as randomly as you can. Now turn it into a picture by coloring and adding details.

Come up with some new chocolate candy flavors, or just illustrate your favorites. Be sure to label them so you remember what they are.

Illustrate this ice cube, but exclusively use warm colors (red, yellow, orange). See if that gives it a whole new vibe.

Cultivate a sense of stillness and balance by drawing a series of "cairns," or stacked rocks.

Cut out a small image from a magazine or newspaper that inspires you, paste it into this space, and try drawing something new around it.

Draw branches starting from the bottom of the page, reaching upward and stretching out. Try slowly stretching your own arms out before and after this exercise, too.

Create a modern art masterpiece of your own by filling the shape with lots of loose lines, then shade in the new shapes going from light to dark.

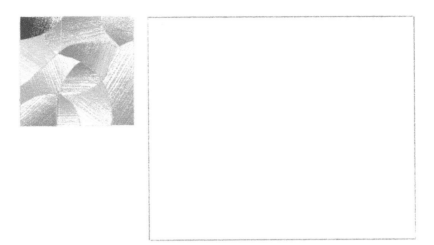

Use a houseplant that can sit next to your drawing area. Put a light source behind it so the shadows cover your paper and draw around them, then color in how you want. If you don't have any plants, try to find another suitable object with interesting shapes.

Finish this quilt pattern with the kinds of squares you'd be able to make with materials you have in your home.

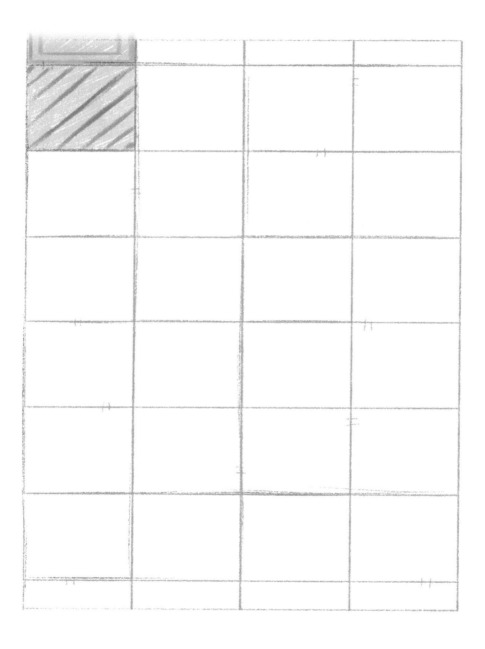

Come up with a new gadget that doesn't exist that could help you in particular during your day-to-day life. It could be a blueprint, the final design, or a design pitch.

Design some silly hats for these folks. Be as practical, fantastical, or nonsensical as you wish!

Try a breathing exercise. For example, breathe in through your nose, count to five, then exhale through your mouth. Now make an abstract illustration of how that exercise feels to perform.

Use your imagination to transform these circles into different objects, such as food, household tools, or animals.

Draw the transitional steps in between these two objects so it looks like a transformation.

Who's a fictional character you adore? Try depicting them in your style here. Get their good side—or their bad side.

Combine four different ingredients into one dish you've never tried. Depict each one on its own, then imagine or describe how you'd combine them. Why did you choose the ingredients you did?

Gourds don't all grow the same way. Model different species of gourds after people, trying to bring out their personality in veggie form.

Rally, Rowdy, Rugged, Resilient. Put some power into decorating these letter R's.

Can you remember a few specific sights from the last walk you went on? Try illustrating one here in the point of view you saw it from.

Use the grid to draw a geometric version of a simple object. The example below shows what a feather might look like in this style. Use only straight lights connected through the grid.

Try drawing different sorts of materials, but color them in extra colorful or artistic ways. For example: galactic wood or fuzzy steel.

Set up a scene to draw using objects from around your house, and draw close-ups from different angles, like mimicking photography.

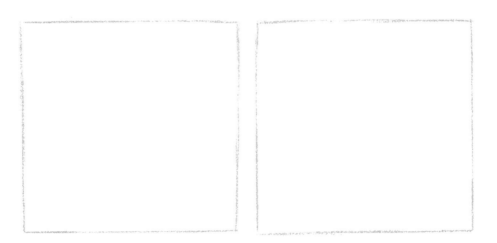

Plaster this page with everything that says "winter" to you. Are there certain activities, environments, events, or foods you look forward to every year?

Fill the space with spirals. Focus on the natural flow of your pen or pencil, and see if you can get your spirals to be more even and round as you go along.

Design a logo that represents something you feel you excel at. Create it as if it were a badge or patch you'd be proud to wear.

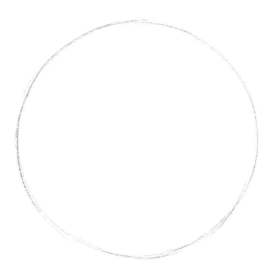

What does kindness look like to you? Illustrate something in this space that makes you think of the power of kindness: an icon, a moment, a person, etc.

Find two different objects with distinctive shapes, and see if you can create silhouettes that make them recognizable.

Whether it's a topic or a person, there's always so, so much more beneath the surface if you go looking. Draw a massive iceberg underneath this waterline.

Draw one of your favorite fashion trends from when you were younger. Do you still think it's in style?

Think of something that relaxes you, and create a cross-stitch pattern themed around it using this grid.

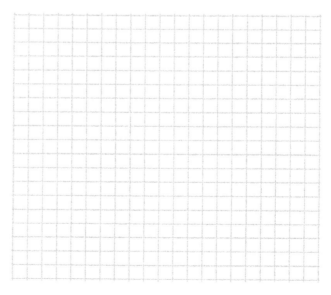

Color a twilight sky above this mountain range. Try making the transition between night and day feel smooth—or go wild and stylish if you prefer.

Design an image depicting something entirely made of words and phrases describing it. Is it more than the sum of its parts to you?

Despite being unable to speak or think, plants are amazingly adaptive and can grow in unexpected places. Draw some plants growing out of this wall.

Create a pattern to fill this space entirely, using many different shapes. Don't overthink; just let ideas come and flow into each other.

Depict a waterfall crashing over a cliff. Try to capture the force of the water tumbling into and over the rocks.

If you could capture a whisper in a jar, what would it look like? How about a scream for the other jar?

Draw two elements of your appearance that someone might recognize, but don't use any facial features.

Imagine a supernatural garden, and create a topiary (shrub clipped into a special shape) that's calming, mysterious, or wacky, to greet visitors.

What sorts of things do you picture when you think of "3 a.m."? Depict what comes to mind.

Create a sparkling winter scene inside this snow globe using only shades of blue.

Soft, Soothing, Sparkle, Special. Think of the ways art affects you as you decorate these letter S's.

Try capturing your most recent meal on the page and write a mini review to go with it. How many stars out of five?

Color the first scene using "golden hour" tones (during sunrise or sunset), then color the second one using "blue hour" tones (right after sunset or just before sunrise).

Make a bold, geometric portrait of a person or character. Use the grid to help, drawing only straight lines. Fill or leave shapes blank where it makes sense to you. Would a friend recognize the end result?

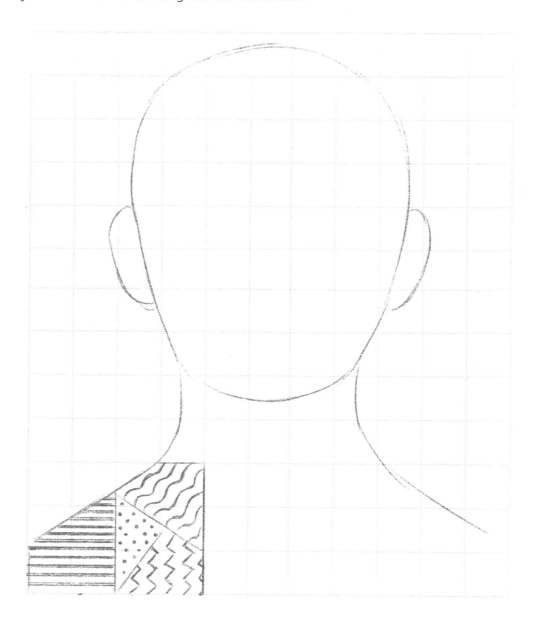

Lightly shade this space with graphite pencil, then use an eraser to try creating a snowflake. Using tools in different ways than expected can help you appreciate their usefulness.

Copy this flower a couple of times, but try to make it appear out of focus each time. What kinds of techniques will you use?

Set up a light source that you can move behind an object. Shifting the light around, draw the shadow three times in the same space, overlapping itself.

Draw two things from your life on this set of scales, and think about how they weigh against each other for you.

Draw something precious to you that you would bury as part of a time capsule to be discovered sometime in the future.

Study your thumbprint, and try to draw it. If you like, try using something to put your thumbprint on the page and re-create it in a new style.

Draw an object from your life using your nondominant hand. Concentrate on the shape and form of the object without worrying about making it look "perfect."

Depict some vases that shouldn't exist. Bend physics, or even time!

Continue the rest of this rainbow ribbon, weaving together different patterns along with the change of color.

Try advertising where you live to encourage tourists to visit. Illustrate recognizable features and landmarks in an appealing way.

Draw in the shadows of the trees to define the landscape. Like these shades, people and the things they leave behind can change how the world looks.

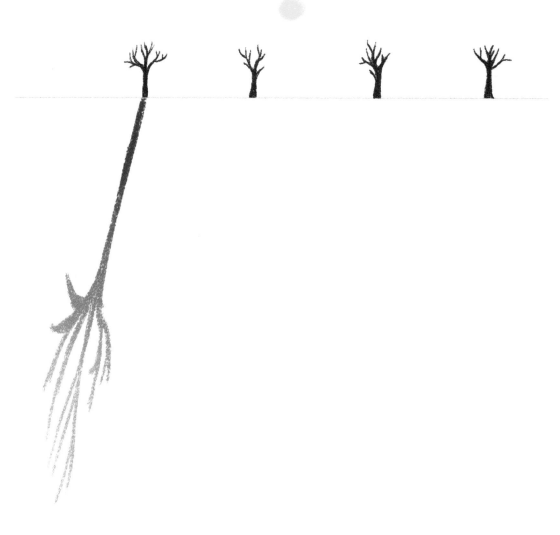

Have your phone handy? Try drawing the 15th most recent picture on it. Otherwise, try finding a random picture you've taken and re-create that.

Put your inventor's cap on, and dream up alternate reality versions of these well-known appliances.

Depict a not-so-secret guilty pleasure of yours here.

Create a scene full of busy worker bees milling about. The buzzing of bees might sound scary, but it's also a sign of vitality and nature thriving.

Depict a bad habit of yours but, alongside it, a good habit you have, too. Do they balance each other out?

As the florist, you've been tasked with getting this place brimming with purple and yellow flowers of many kinds—as many as you can muster!

Try to draw something a friend describes to you that you know nothing about—a hobby, a piece of media, a person, etc. Ask them to make the description vague but fun, and see what you come up with.

Illustrate clouds in this sky, but limit yourself to using only single, disconnected lines. Observe this example of contour drawing to get an idea of how this technique works.

Use the first frame as inspiration to fill in the other two. Try copying the minimalist art style exactly in the second frame, but re-create the image in any style you like for the third.

Create a pattern to camouflage this moth. What kind of environment is it blending into?

Technical, Terminology, Theories, Transmission. Think about the complicated ideas people need to share with one another to create new technology as you decorate these letter T's.

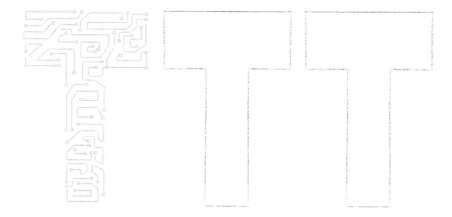

Illustrate this page to the max with some '80s-inspired pop art—the kind you'd see used in old advertisements.

Draw something abstract that only exists for a short moment of time (for example, a single drumbeat). By capturing it in art, how is the experience of that thing altered?

Draw some random shapes that are evenly spaced apart, then use shading and coloring to make them look three-dimensional.

You've found a buried treasure chest. What could be hidden inside that would excite you most?

Think of someone you know well and, without including their face, draw something that you would recognize as being from that person. It could be a particular hairstyle, for example, or something they wear a lot.

Draw a large flock of starlings flying south for winter. It can be awe-inspiring to see so many creatures moving in tandem.

Try thinking of a seemingly small event that led to a chain reaction that changed your whole life. As you do, draw the ripples from these skipping stones while you link the events together.

When you're on your way home at the end of a long day, what are you looking forward to most? Depict it here in a way that shows how it makes you feel when you come home.

Ultra, Upward, Unyielding, Ultimate. Think of a sense of unstoppable power as you decorate these letter U's.

Contour drawing is about depicting an object using only its outline. Draw some faces using this technique with a single line each, not taking your pencil off the paper.

Try setting up a scene to illustrate as a color still life image, but avoid sketching or outlining the shapes of the objects, instead leaning into a soft, blurry style.

Complete this triptych landscape using your imagination. Does it tell a story?

Try depicting the weather around you right now through this window. How can you portray it properly through a limited space?

Draw and color the missing halves of these objects using their complementary colors.

Fill the space around this arrow with a bunch moving in opposite directions. Give them creative styles and colors so each is distinct.

Draw a whole apple, then illustrate different phases of it being eaten. Have a real one as a snack for reference if you like.

Come up with a badge representing a precious moment in your life. How can you simplify it into a clear, recognizable pin design?

Try illustrating some balloons swirling in a whirlwind. Think of people in your life who have come and gone but left an uplifting impact on you.

Draw the scene around you in the style of a stained-glass mural. What features take prominence? What kinds of colors or shapes should you incorporate? Can you portray it in a way that evokes awe and wonder?

Using only abstract shapes and patterns, try depicting a feeling of freezing cold.

Fill these bottles with magic potions, using different colors and techniques to give each one a unique feeling. What kinds of effects do these concoctions cause?

Draw the perfect mug for you. What size, shape, and design will it have?

Versatile, Vibrant, Vitality, Valor. Envision explorations into nature as you decorate these letter V's.

Turn this book upside down, and draw a quick and simple landscape. Flip the book back over, and color your drawing so that the top looks like a sky.

A Zentangle is an abstract piece of art created by combining patterns. Use this scaled-down example to try experimenting with the format, and let yourself enter a meditative state of mind.

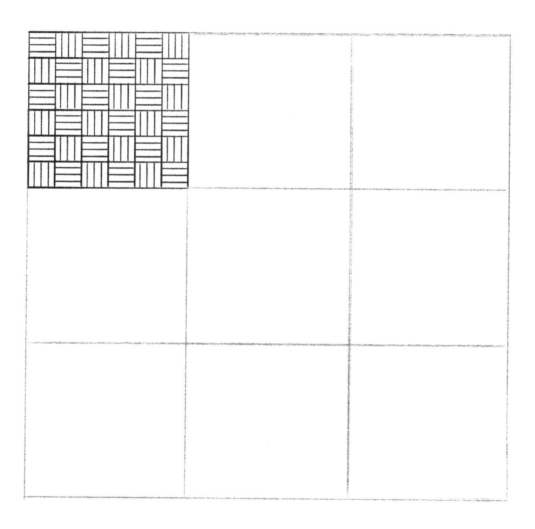

Draw four things that you are grateful for in your life. Try depicting them each in a different art style.

A seed is potential and possibility. Imagine some element of your life that has grown a lot over time, and try depicting it growing from this seed.

Draw a symbol that represents your favorite movie or TV series—something other fans would recognize but those who haven't watched might not.

Imagine new planets have been discovered near our solar system. Draw these new worlds, and think of what their surfaces might look like.

Fill this section with everything pink! Think of unexpected objects that may be fun to draw and color.

Draw something you love and cannot live without, then flip the page upside down and draw something you hate beside it. Try thinking of two things that might match well in an illustration together.

Design a new statue for the place where you live. Would it be of someone local you know well? A certain object or an act of service? A well-known landmark?

Draw an abstract deconstruction of the illustration, and then choose two objects near you and do the same with them.

Winner, Work, Wisdom, Worthwhile. Try representing some of your personal victories as you decorate these letter W's.

Draw something that has made you cry beside something that has made you laugh. See if you can work them together into one illustration that feels cohesive.

Create a star sign to represent a part of yourself. Write a horoscope to go along with the constellation you've made!

Think of or find something black and white, and illustrate it with a color palette.

Stippling is a technique where an image is created using a series of dots—no lines or strokes. Try your hand at stippling, and make an illustration purely using one color and only with dots of a similar size.

Fill this page with words describing how you've been feeling lately. Try to be honest with yourself! Then color around the words with expressive strokes to visualize these feelings.

Draw and decorate a batch of cookies, including all your favorites!

Xylographic, Xenomania, Xenagogue, Xaern. Think of a passion you found that was unexpected and surprising as you decorate these letter X's.

Use the first frame as inspiration to fill in the other two. Try copying its impressionist art style closely in the second frame, but invent your own style for the third.

The aurora borealis is a result of solar winds interacting with Earth's magnetic field, creating a colorful, surreal display. Add the northern lights to this scene.

Draw a self-portrait by looking at your reflection in a spoon or some other curved object. What features help this distorted image of yourself stay recognizable?

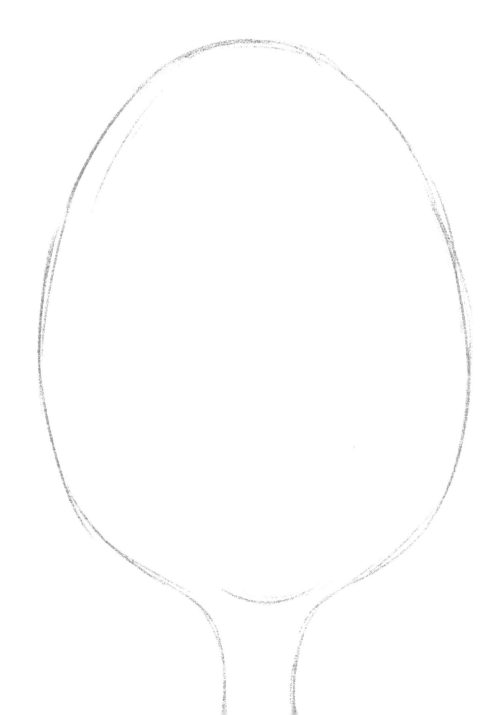

Fill the space with abstract shapes and lines that represent the following words: "irritate," "soothe," "shock," "flow."

Snack emergency drill! Draw three things that are in your refrigerator right now that you'd be most likely to grab if you needed a quick meal.

Try amping up the energy of this typography with any techniques you like.

Visualize your day by continuing this red thread and not breaking the line. How can you interpret any positive or difficult moments?

Decorate this holiday tree with some festive ornaments. They can be based on your favorites, if you want!

Yip! Yeah! Yell! Yay! Make these letter Y's feel like they're being exclaimed with excitement.

Try designing the comfiest chair, hammock, or couch you can come up with, someplace that exudes coziness where it'd be pleasant to spend a long afternoon relaxing on a stormy day.

Draw a row of trees, but use different styles and patterns for each one.

Draw some colorful petri dish art. Try to depict it blooming and multiplying in an illustration.

Draw some graffiti on this wall. What kind of message or idea would you want to convey through graffiti?

Draw a dish that your region is well known for! Would you put it on a tourism ad?

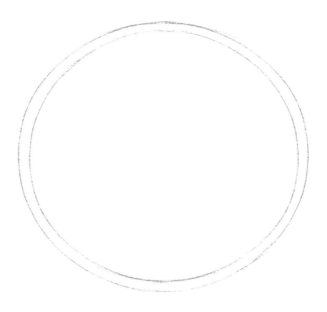

Use color and abstract shapes to express these different genres of music, then choose another genre yourself and create the typography and design for it.

JAZZ

ROCK

Illustrate all manner of light bulbs to hang on this display. Draw different shapes and colors, and try shading in some lighting to set an atmospheric tone that vibes with you.

Zazzy, Zeal, Zest, Zingy. Decorate these letter Z's in a way that feels classy and celebratory as you near the end of another year.

Fill this space with clouds, and try depicting or writing dreams you have in some of them.

This frigid lake is frozen over. Think back on a particularly cold day you endured. How can the emotions and memories from that day inspire you as you portray the frost and snow covering the frozen lake starting from the shoreline?

Express what a "silent night" means to you in an illustration. Are you asleep or awake?

Draw yourself in this "broken mirror," using each space to draw a different angle or close-up of yourself. Or get even more creative and use each fragment to show a different side of your personality.

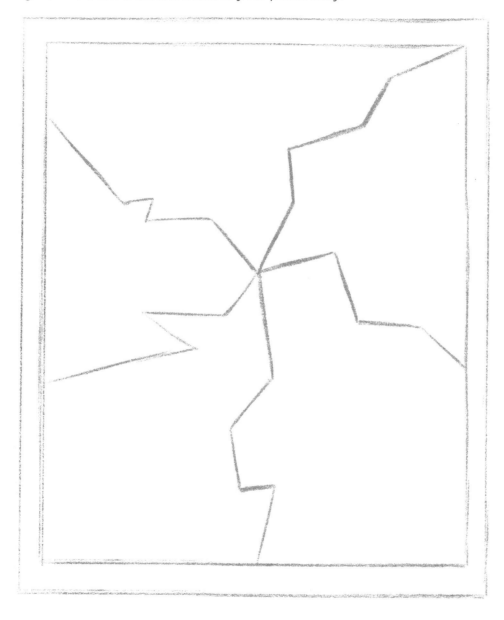

Draw a collection of uniquely designed snowflakes. Have some fun, and create their designs based on people you know.

Design a life map. Start in the present, think about your future goals, and make them places to visit on a map. You can add an end destination or have it extend off the page.

Design the wrapping paper for a holiday you'd like to receive or give a gift during.

Create patterns for these dresses using abstract lines and small shapes. They could share a theme or have entirely different styles.

Draw swirling patterns of smoke rising from these chimneys, and think of how hearths used to be the gathering spot of a home.

Re-create a positive moment from the last week, and try to do so in a way that isn't obvious. Be abstract, stylistic, or creative.

Illustrate three different types of weather captured in these bottles. Make them feel like they could burst out at any moment.

What represents "strength" to you? Draw it below as you reflect on the strengths that you possess.

What or who gives you a sense of stability in your life? Decorate this anchor in a way that expresses that.

It's been a full year! Think back on everything you've learned, and try capturing the most important ideas and lessons into a collage illustration to finish the year off strong.

Resources

Artists, especially budding artists, should be visiting galleries and exhibitions as often as possible. But when that's not possible, here are some websites you can check out.

Connect with artists and galleries on Pinterest, Behance, and Instagram.

Pinterest.com
Behance.net
Instagram.com

Exploring Artists Through Their Sketchbooks

EtchrLab.com/blogs/news/exploring-sketchbooks

The Sketchbook Project

SketchbookProject.com

Unseen Sketchbooks

UnseenSketchbooks.co.uk

For artist materials at a fair price, check out:

IlloSketchbook.com

Inktober is a great challenge with a supportive community—31 drawings over the 31 days of October.

Inktober.com

CPSIA information can be obtained
at www.ICGtesting.com
Printed in the USA
JSHW021121150122
21878JS00003B/3